A HOW-TO FOR BEGINNERS

DRILLS, PROJECTS & PRACTICE!

Lettering for Beginners Workbook

[©] Lettering for Beginners Workbook. All rights reserved. No part of this publication may be reproduced, distributed, or transmitted, in any form or by any means, including photocopying, recording, or other electronic or mechanical methods, without prior written permission of the publisher, except in the case of brief quotations embodied in critical reviews and certain other noncommercial uses permitted by copyright law.

TABLE OF CONTENTS

INTRODUCTION	4
LETTERING INTRO	5
TOOLS	7
ALPHABET GUIDES	8
PRACTICE WORDS	41
PROJECTS	64

Hi, friends! This book is jam packed with lettering goodies to get you started on your lettering journey! You'll find lots of different alphabet styles, projects & practice pages to help you master this new skill! The most important part of this journey is truly practice, practice, practice! As you memorize each stroke, your muscles will commit each letter to memory and that is when the fun begins. Once you have mastered your alphabets, you can begin to really create custom lettering art. So, use all the space provided to you for practice in this book! You can also buy tracing paper and layer it over the pages of this book for additional practice, tracing over letters and words! Ok, are you ready? Let's do this!

LETTERING INTRO

Let's get started by going over some lettering basics!

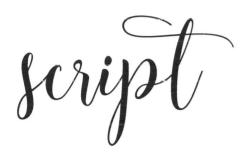

SCRIPT This lettering style mimics calligraphy or cursive. It is a favorite among many because of the flow and beauty of each stroke!

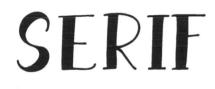

SERIF This alphabet style is popular because it is the easiest to read. Serifs are the small strokes added to the end of each main lettering stroke.

SANS SERIF

SANS SERIF This lettering style can be very playful and add a nice contrast to the elegant flow of script! You'll see that this lettering style is similar to the serif but without the small strokes on the top and bottom. The word "sans" means without in French, so this style is without serifs!

LETTERING INTRO

Lettering is simply the art of drawing letters. It is a skill that is learned and perfected with practice! You do not have to have nice handwriting in order to succeed at lettering, you just have to commit to practicing!

downstroke

The very basic makeup of letters consists simply of upstrokes and downstrokes, right?! You'll notice that all of the downstrokes are always thicker than the upstrokes. When you are using tools such as calligraphy pens and brush pens, you use pressure to create thicker strokes. However, in this book we will focus more on hand lettering, which means we will simply fill in the downstrokes and create a thicker line with whatever pen, pencil, or marker you choose to use! This is such an easy way to acheive the look of calligraphy! In this beginner's workbook, we'll focus on this simple theory and use our time to practice the different styles and form of each letter!

TOOLS

The beauty of hand lettering is that you really only need pencil and paper to begin! However, you can spice it up by using a few different mediums we'll discuss below!

PENCILS

The easiest tool! Grab a mechanical pencil and you can letter anywhere!

PENS

Micron Pens come in a variety of sizes and are great, high quality lettering pens. Sharpies are also a fun medium to try!

COLORED PENCILS

Try Prismacolor Pencils to add depth and a pop of color!

MARKERS

Whether you buy Crayolas or a nice set of alcohol markers, this medium can provide beautiful results!

WATERCOLOR

Once you've mastered pen and pencil, watercolors provide an amazing new challenge for your lettering journey!

CHALK

If you love the look of black and white lettering art then chalk may be your new favorite medium! Chalk gives you the opportunity to use the chalk dust to create depth & shadows!

ALPHABET GUIDES

LOWERCASE SCRIPT ALPHABET

abid of Z hijklan 0 p g r 8. l'u vwxyz ON THE FOLLOWING PAGE YOU WILL BEGIN LETTER DRILLS FOR THIS LOWERCASE SCRIPT ALPHABET! REMEMBER THAT LETTER DRILLS ARE THE BASE FOR MASTERING HAND LETTERING SO THERE IS EXTRA SPACE TO PRACTICE. PRACTICE, PRACTICE! LET'S BEGIN ...

a a a a a a a a a a a 66666666 0 0 0 0 0 0 0 0 0 0 0 0 d d d d d d v v v e e e e e e R R R R 999999 h_{1} h_{2} h_{1} h_{2} h_{3} h_{4} h_{1} h_{2}

i 80 7 k_{\prime} -M/M/M/M/M $\eta = \eta = \eta$ O O O ppp 12

9 9 9 9 N N N X X X t t t4/4/4/ 12 12 12 ns ns ns χ χ χ

y y y 3 3 3

UPPERCASE SCRIPT ALPHABET

ABCDEF GHJJKLMA NOPORS TUUNXYZ

ON THE FOLLOWING PAGE YOU WILL BEGIN LETTER DRILLS FOR THIS UPPERCASE SCRIPT ALPHABET. AS WITH THE FIRST SET OF LETTER DRILLS, THERE IS EXTRA SPACE TO PRACTICE. DEVELOPING THAT MUSCLE MEMORY WILL BE KEY WHEN YOU START TO WRITE WORDS! LET'S GET STARTED...

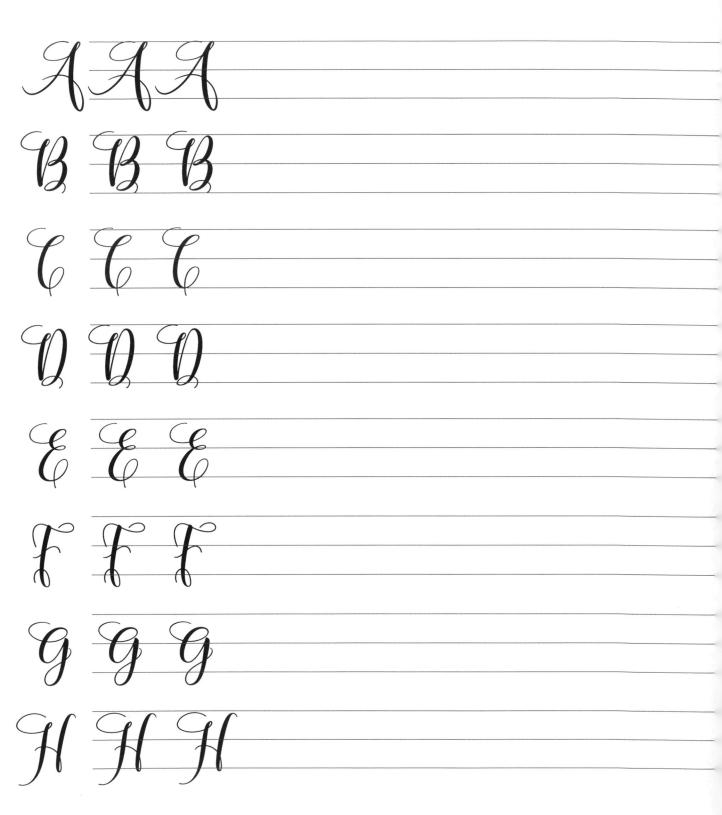

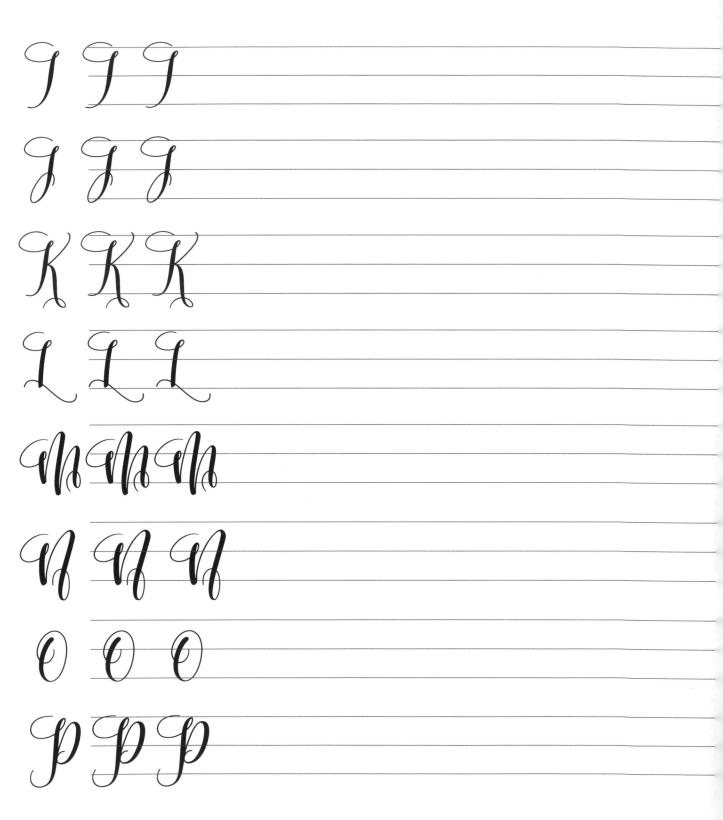

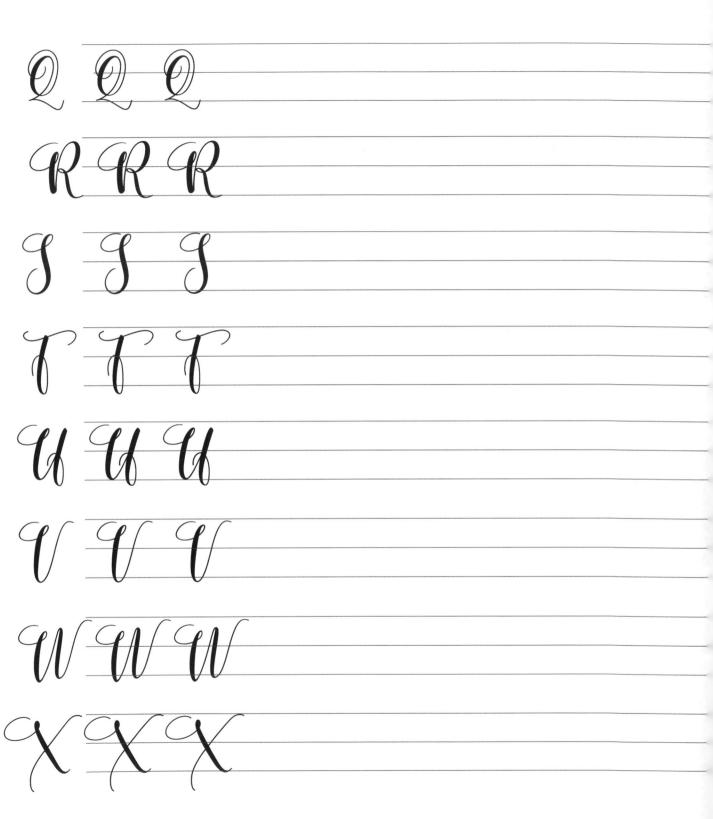

5		
3		
l		
<u></u>		
		Sager - C
× ×		
	-	
2		

Y Y Y

UPPERCASE SANS SERIF ALPHABET

ABCDEFG HIJKLMN OPQRSTU VWXYZ

THIS IS AN EXAMPLE OF A SANS SERIF ALPHABET. THIS IS THE PERFECT STYLE TO MIX AND MATCH WITH YOUR SCRIPT LETTERS. WHILE THIS ALPHABET MAY LOOK EASIER TO WRITE, IT STILL TAKES PRACTICE AND MUSCLE MEMORY TO MASTER! LET'S GET PRACTICING...

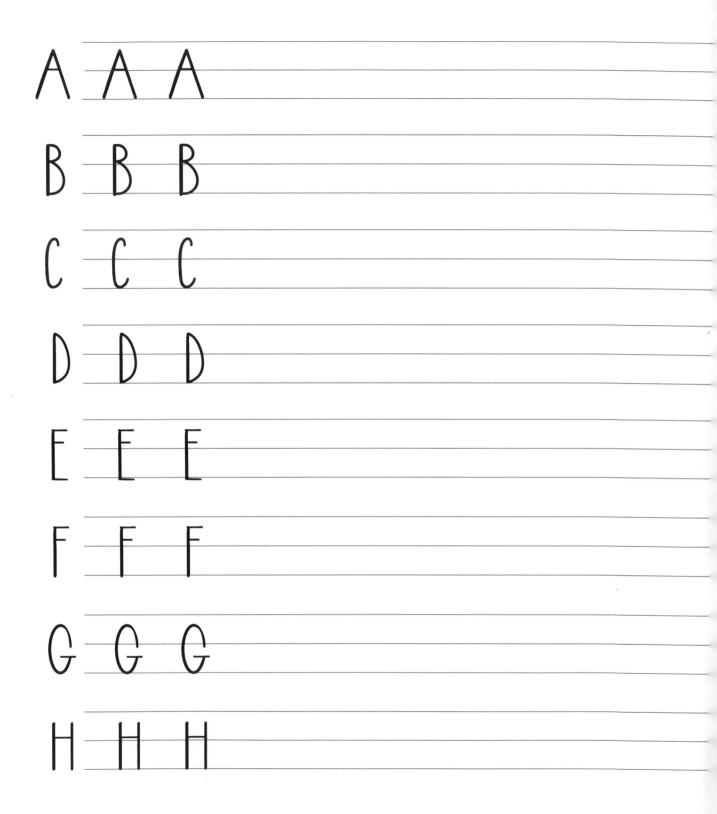

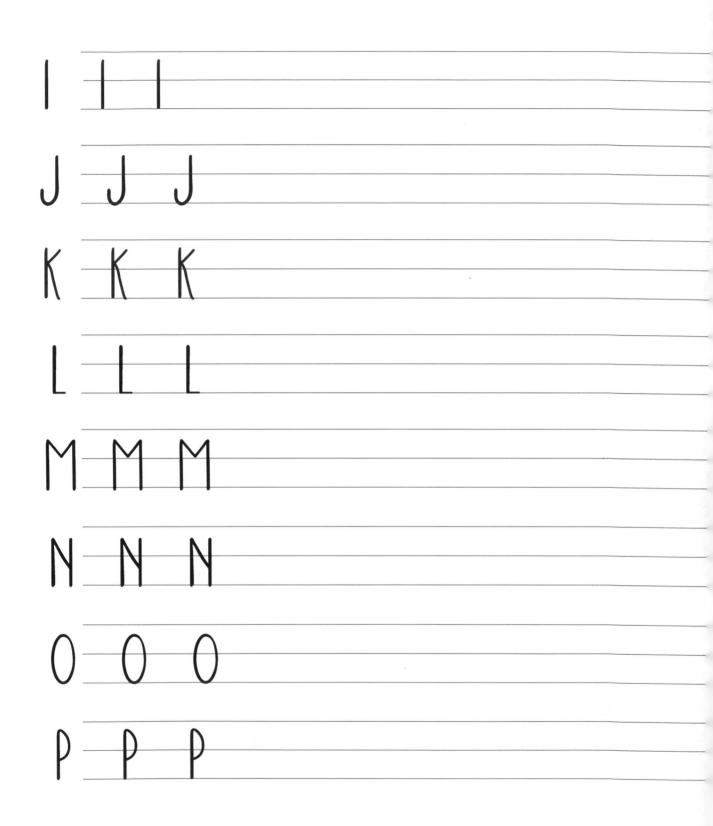

Y Y Y 1 1 1

UPPERCASE SERIF ALPHABET

A B C D E F G H I J K L M N O P Q R S T U V W X Y Z

THIS IS AN EXAMPLE OF A SERIF ALPHABET. THIS IS ANOTHER FUN STYLE TO MIX WITH YOUR SCRIPT AI PHABET LETTERS. THIS ALPHABET REQUIRES YOU TO FILL IN THE DOWNSTROKES AS WELL AS ADD THE SERIF TO THE TOP AND BOTTOM OF EACH LETTER. LET'S START PRACTICING...

)	 				
)	 	 			
	 	 			-, (9)
				1961.1	
	 		-		

V	YY
7	11
L	

PRACTICE WORDS & PROJECTS

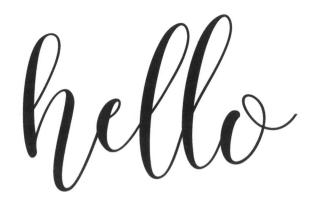

TRACE:

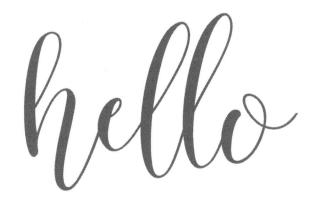

MAN NO

TRACE:

220

congral

TRACE:

gra w PRACTICE:

TRACE:

bloon,

TRACE:

bloon,

heart

TRACE:

andforme

TRACE:

andforme

TRACE:

beautiful

TRACE:

beautiful

Sushine

TRACE:

Sushine

ppy har

TRACE:

M PRACTICE:

TRACE:

adverture

TRACE:

adverture

hooray

TRACE:

hooray

PRACTICE WORD: sparkle TRACE: sparkle PRACTICE:

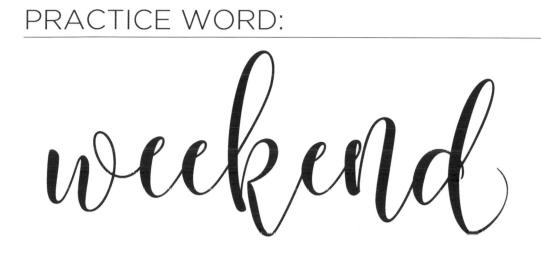

TRACE:

veepend)

hers

TRACE:

chers

kindness

TRACE:

kindness

1

TRACE:

coffee

TRACE:

shine

TRACE:

shine

DON'T FORGET TO BE

PROJECT 2:

PROJECT 3:

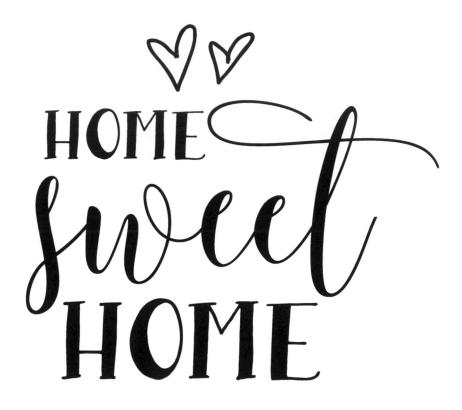

PROJECT 4:

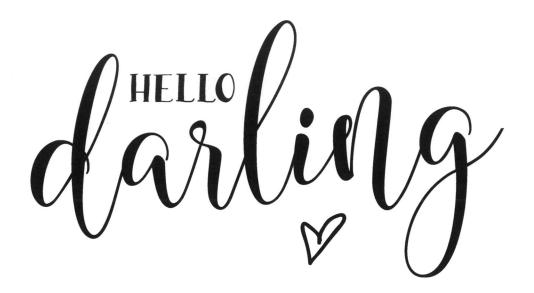

PROJECT 5:

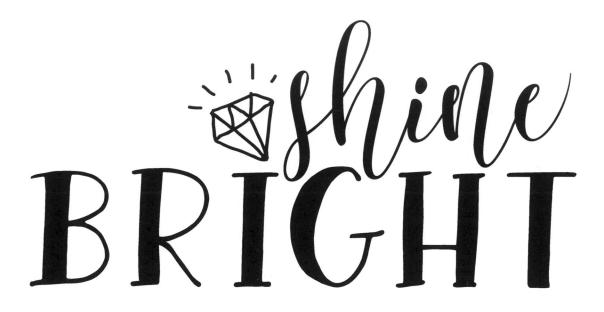

73

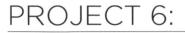

PROJECT 7:

WANT MORE GOODIES?!?!

Head to the following link to download NEW (FREE!!) practice words and projects!!

www.letteringdesignco.com/letteringforbeginners